200 Words to Help You Talk about Art

Laurence King Publishing

200 WORDS

to Help You Talk about

ART

Ben Street

Contents

The Media
of Art

Photography

Techniques
of Art

Objects of Art

Art Movements

Art Styles

Art Concepts

Art Forms

The Art World

Art Spaces

The Media of Art

Tempera

Tempera, a mixture of raw pigment and egg yolk, was
the principal medium in Western painting up to the
advent of oil paint in the fifteenth century. Painters
applied tempera to wooden panels with short strokes
of a brush, adding darker colours over lighter ones
due to the relative translucency of the medium. The
density of yolk created an effective medium for colour,
and the easy availability of eggs meant that the cost
of tempera could be kept fairly low. Tempera tends
to look somewhat chalky in colour, and has a limited
range of tones available due to the natural lightness
of the mixture.

Fresco

A fresco is painted directly *into*, rather than *onto*,
a wall or ceiling. Pigment is mixed with wet plaster and
applied in sections onto a surface. As the mixture dries,
it bonds with that surface. This initial layer is known
as 'true fresco' (*buon fresco* in Italian); anything applied
on top is known as *fresco secco*, or 'dry fresco'. Artists
often used cartoons (full-size preparatory drawings) to
transfer a large drawing onto a surface, and then applied
the coloured fresco in sections called *giornate* (*giornata*
means 'day's work'). Fresco artists, painting on high
wooden scaffolding, would work methodically, as the wet
plaster dried quickly, especially in warmer weather.

Silk Screen

Silk-screen printing, also known as screen-printing, is a technique that originated in a commercial context. It first started to be employed by artists in the early decades of the twentieth century, and is probably best known in association with Andy Warhol's work from the early 1960s. A large piece of fabric – sometimes silk, sometimes a synthetic material – is stretched over a frame. Parts of that fabric are then blocked off using stencils or an opaque material, such as lacquer. The parts not blocked off will allow the ink to bleed through. Artists' prints created with silk screens are sometimes known as serigraphs.

Etching

Etching is an intaglio technique, in which designs are cut into a surface. To make an etching, artists start with a thin copper plate coated with an acid-resistant material. They then draw into the surface with a tool, making lines that penetrate through to the copper layer. Once finished, they dip the plate into an acid bath. Anything not covered with the acid-resistant material is eaten into by the acid. The artist rolls ink over the cleaned surface, then places a piece of paper on top. The plate and paper are passed together through a printing press, creating a print, a reverse impression of the original drawing.

Engraving

To make an engraving, artists incise their designs directly into a metal plate using a metal tool with a shaped tip called a burin. Artists can create a wide range of marks by using different burins, and can create darker or lighter lines by applying more or less pressure. As with all prints, the surface of the plate is then inked and a piece of paper is placed on top, then both are passed through a printing press, producing the final print, which is a reversed impression of the original design. Because of the durability of the plate (usually made of copper or zinc), multiple impressions can be made of a single engraving or etching.

Aquatint / Mezzotint

Intaglio printmaking is sometimes combined with aquatint, a technique used to render large areas of light and shade. After an etching has been made, powdered resin is applied to the plate and melted onto its surface. When the plate is dipped into an acid bath, the acid eats around this resin, creating a tonal, painterly effect, such as in the prints of Francisco Goya. In mezzotint, the technique that preceded aquatint, artists used a metal tool called a rocker to make tiny marks on the plate's surface that suggested light and shade.

Collage

In collage, images are created by sticking various
materials to a surface. The term derives from the
French *coller*, 'to glue'. Around 1912, cubist artists
Georges Braque and Pablo Picasso incorporated
scraps of wallpaper and newspaper into painted
canvases to create collages. The fragmentary nature
of the medium seemed apposite in a turbulent modern
world. Sculpture, too, can be composed of diverse
found elements, and cinema from the 1920s onwards,
especially in the USSR, used montage to create jarring
effects. Sampling in music, the foundation of hip-hop
in the 1980s, can be considered an audio form of collage.

Video Art

Video emerged as an artistic medium in Europe
and the United States in the early 1960s and, at
that time, was often related to conceptual and
performance art. The mass-culture medium of the
moving image proved compelling for artists whose
interests lay in the examination of images and the
narratives of modern life. With the gradual recognition
of video as a form of art came an increase in budgets
and institutional support, and production and display
standards rose accordingly. Though a very young form,
video art contains a huge diversity of approaches, from
lo-fi collage to feature-length films.

Daguerreotype

Although the technique of projecting an image of the world inside a darkened room (camera obscura) had been known for centuries, making that image permanent by fixing it onto a surface was only achieved in the 1830s. The French artist Louis Daguerre pioneered a process that was one of the first successful attempts to do so. Daguerre's images, known as daguerreotypes, were made with silver-plated copper sheets that were treated with iodine fumes. By exposing these sheets to light, a sharp image of reality was captured, but it could not be reproduced. Daguerreotypes required long exposure times, and subjects had to remain very still throughout; failure to do so resulted in blurred images.

Gouache

Gouache is a painting medium composed of pigment, water and a gum binder. It somewhat resembles watercolour but is thicker and more opaque, and so creates stronger and more powerful effects of colour. Because it dries quickly, gouache is often the medium of choice for artists working en plein air who want a more substantial quality to their work than watercolour can provide. Gouache can easily be combined with other media: the British artist J.M.W. Turner used white gouache on his pencil sketches to create the effect of highlights.

Watercolour

Watercolour paint is made by suspending raw pigment in a binder, usually gum arabic (derived from the sap of the acacia tree) mixed with water. Watercolour is generally used on sheets of white paper, where its thin consistency allows the brightness of the paper to show through, giving a general effect of radiance. Areas of the paper are often left unpainted to evoke highlights, or white gouache can be used for the same function. Because of its delicacy, watercolour is a challenging medium, although it is ideal for plein-air landscape painting, as it dries quickly and can be applied at speed.

Acrylic

Acrylic paint, which first started to be used by artists in the 1960s, consists of a mix of pigment and synthetic resin. Because acrylic is water-based, it tends to dry quickly, and can be diluted with water to give a range of painterly effects that can resemble watercolour. Acrylic tends to dry to a matt finish and lacks the rich tonality of oil paint. British artist David Hockney made use of acrylic's distinctively flattened surface effect when painting the pools and private residences of Los Angeles in the 1960s.

Oil Paint

Oil paint consists of raw pigment suspended in an oil medium, usually linseed or walnut oil. Because it is very slow drying, oil paint enables artists to make gradual changes to their paintings over time, something often revealed in *pentimenti* (faded areas through which under layers show). Oil is a diverse medium, allowing for thick, gooey impasto and wet-in-wet blending, as well as thin, translucent glazes and subtle tonal ranges. Oil holds colour efficiently, creating rich depths and subtle realism in the depiction of flesh, fabrics and textures. For these reasons, oil became the medium of choice for portraits of individuals from the Renaissance onwards.

Encaustic

Encaustic is a painting medium in which raw pigment is suspended in melted beeswax. It is generally applied to wooden panels and is associated with ancient paintings, especially the Fayum mummy portraits from Roman Egypt (around 100–300 CE). Encaustic is a versatile medium that dries quickly and generally holds its colour; it can be reheated once applied to allow colours to blend more effectively. When painted in layers it can achieve a luminous quality. Encaustic has more or less fallen out of favour in modern times, although some artists have revived it, most famously Jasper Johns, who used encaustic in his paintings of the American flag from the 1950s.

Mosaic

Mosaic is an ancient form of decorative art used to cover large surfaces, traditionally the interiors of religious buildings. A mosaic is composed of thousands of small pieces of glass, ceramic or marble, which are permanently affixed to a surface, such as a ceiling, wall or floor, but sometimes also a portable panel. If mosaic is laid down in a slightly uneven manner, it will reflect light in diverse ways, seeming to glitter; this is often seen when glass tiles containing gold leaf are used on ceilings. Micromosaics, made from tiny pieces of glass and often indistinguishable from paintings, became very popular in the nineteenth century.

Edition / Multiple

In printmaking, cast sculpture, video art and photography, the words edition and multiple describe identical copies taken from a master. A multiple is a copy that exists as part of a limited edition. Maintaining this limit is crucial to establishing the value of a single multiple: the larger the edition, the less unique the work, and therefore the less valuable it is. Sometimes the size of the edition is determined by the process of reproduction itself, as the master might be damaged in the act of creating the multiple.

Lithography

Lithography, meaning 'stone writing', is a printmaking process in which artists draw an image onto a stone surface using a greasy material such as a crayon or pencil, much like a conventional drawing. After the drawing is finished, the stone is treated with chemicals that eat into the unmarked areas of the surface. The whole area is then moistened with water. When oil-based ink is then applied onto the stone using a roller, it will cling to the greasy drawn areas and be repelled by the water. Prints are then made directly from the stone. In more recent lithography processes, metal plates are used.

Ceramic

Ceramic describes anything made from clay, shaped in a process called pottery, and dried in a hot kiln. The term covers a range of materials, including porous earthenware, tough and translucent porcelain, and thin bone china. Chinese ceramics, which date back to the seventh century CE, are the most sophisticated and diverse objects in this medium. Ceramics can be glazed using powdered and melted glass (known as enamel) or other kinds of glaze made with tin, lead or salt. Glazing protects the clay, controls its porosity, and allows decorative colour and pattern to be used.

Woodcut

A woodcut, a form of relief printmaking, involves gouging into the surface of a block of wood to prepare a design to print from. The block is then thoroughly inked and run through a printing press with a piece of paper. The ungouged or raised areas of the wood will retain the ink and impress the image onto the paper. Artists sometimes work with professional woodcutters, who gouge out the surface of the wood following a preparatory drawing supplied by the artist. Colour woodcuts, which could generate a wide range of painterly effects, were developed in Japan in the eighteenth century.

Metalpoint

Metalpoint is the ancestor of the modern pencil. Since classical Greece (about 500–300 BCE), artists used pieces of soft metal to draw onto paper; lead was popular, as were copper and tin. More permanent drawings could be made using silverpoint on a ground prepared with gesso, a mixture of chalk or white pigment with a binder: the silver oxidizes in air and turns brown. During the Renaissance, artists used silverpoint drawings as preparatory sketches or to instruct an assistant. Metalpoint was often used to create underdrawings, which were sketched onto a canvas or panel surface before colour and tone was applied. These are often revealed by infrared radiation.

Handscroll

Chinese handscrolls offer a uniquely intimate experience for the viewer. Placed on a flat surface, they are then unrolled with the right hand using a wooden cylinder, while the left gathers the sections already seen. The painted surface is revealed over time, section by section, a little like a film, allowing the artist to develop a narrative sequence and employ the element of surprise. Handscrolls are always kept rolled up when not being read, for both preservation and portability, and they are often embellished with stamps that indicate their owners and even written interpretations of the scenes they depict.

Pentimenti

Thanks to the unpredictable behaviour of paint, what lies beneath the surface of paintings is sometimes unexpectedly revealed. With the development of new forms of paint in the fifteenth century – specifically, oil paint – artists were able to act more spontaneously in the making of their work. While previous forms of paint – such as tempera, which was mixed with egg yolk – required careful application of thin layers of delicate colour, denser, richer oil paint allowed for changes. As oil paint fades, these earlier decisions float to the surface: a ghostly figure may emerge, or pale additional limbs sprout from a horse's body. They are known as *pentimenti*, from the Italian, meaning 'repentance' or 'correction'.

Craquelure

Visible on many old paintings are networks of fine cracks, especially where the paint is at its thickest. This effect is known as craquelure, and it can reveal much about the painting's past: how it has been treated, and even the painter's technique and mixture of paint. The older a painting, the more potential or actual damage it has received; conservation treatments can sometimes reduce the visual effect of craquelure, but an active viewer will usually still see it. It is a reminder that works of art are frail physical objects, in need of maintenance and care.

Photography

Calotype / Wet Collodion Print

Pioneers of photography, inspired by the daguerreotype, sought a means to create negatives so that photographs could be reproduced. The calotype, invented in the 1830s by the English scientist William Henry Fox Talbot, used chemically treated paper to create negatives, which were then used to make positive prints. Wet collodion, developed in 1851 by Frederick Scott Archer in Great Britain and Gustave Le Gray in France, used a glass plate coated with collodion (cellulose nitrate) that stayed wet when the picture was taken. The image was then printed in a darkroom. Both techniques required heavy equipment and containers of toxic chemicals; these were replaced in the later nineteenth century by the invention of film cameras, produced by Kodak.

Gelatin Silver Print

Fundamental to analogue photography is the application of light-sensitive material to a surface. Gelatin silver prints, the most common analogue black-and-white photographic medium today, were developed in the late nineteenth century. Gelatin, containing silver salts, was used to coat a surface, such as flexible film. This process replaced albumen prints, which used egg white, salt and silver nitrate. The stability of gelatin silver prints and their ease of production made them a more effective alternative to albumen. Most modernist photographers used this process, which was widely available, non-toxic, and could be printed onto various kinds of paper, creating a range of effects.

Chromogenic Print

Chromogenic prints – usually known as C-prints or C-type prints – became popular among artists in the 1990s due to their rich colour, sharpness of image, and quality when printed on a large scale. C-prints begin as colour negatives, which are then exposed to photosensitive paper with at least three layers of emulsion, each one sensitive to a different colour. When chemically processed, these layers react and create a vibrant effect. Because the materials of C-prints are inherently unstable, over time, the colours can fade, and they are extremely sensitive to light. Most colour photography uses this process.

Digital Photography

Digital photography uses light-sensitive pixels to receive an image through a lens. The image is then stored as digital information, which can be printed using a variety of processes. The most common is inkjet printing, in which a digital image is recreated with small drops of ink on paper. Digital images can be manipulated and transformed on a computer, and the possibilities of the medium are constantly shifting. A digital image can be used as part of a sculptural practice, incorporated into painting, or might exist solely online. The circulation of images on the internet has only increased photography's central place in contemporary politics, social life and economics.

Photogram

A photogram is a photograph made without a camera. A sheet of paper or piece of film is prepared with light-sensitive chemicals. The artist then places an object on the surface, or presses a body part to it, and exposes it to light. Any covered areas remain unexposed and appear as bright white, while exposed areas turn black. This technique became popular among modernist artists in the first decades of the twentieth century. The surrealist Man Ray made photograms that he called 'rayographs', in which he created bizarre juxtapositions of objects and human silhouettes that remain influential among artists.

Photomontage

Photomontage is a form of collage composed of found or original photographs. Because of its relationship with the distribution of images in the mass media, it is often associated with political protest; it was developed by Dada artists around 1915 as part of their expression of disgust at the condition of war. Dadaists often sought a turbulent, fragmentary aesthetic in their photomontages, which reflected this dissent, but other artists, especially those of the surrealist movement, seamlessly joined photographic sources, creating uncanny images that reflected the free associations of the unconscious.

Decisive Moment

Henri Cartier-Bresson coined this term in the 1950s to describe a single moment in time in which people and places reveal hidden meanings. Capturing this moment was, for Cartier-Bresson and the many photographers he inspired, the essence of photography. In such a photograph, serendipitous geometries and compelling ironies are captured by the camera, or perhaps more precisely, created by it. Cartier-Bresson's attitudes have long been dismantled in much photography, as artists became increasingly frank about the artifice of the endeavour and the complex ethics of photographing strangers unawares, but his influence on photojournalism and street photography endures.

Techniques
of Art

Perspective

The techniques and theories of perspective were formulated during the Italian Renaissance, particularly in Florence, around 1420. Single-point or mathematical perspective proposed that an illusion of deep space could be created by making all lines in a drawing meet at a single spot, known as the vanishing point. In other cities at around the same time, notably in Venice, artists created a variation on this technique, using subtly graded colour variation to evoke distance, rather than straight lines. Known as aerial or atmospheric perspective, this was truer to our experience of space, in which distant objects do seem paler than those close to us.

Vanishing Point

When artists of the fifteenth century were developing linear perspective, they created a simple illusion of receding space by placing a dot – the vanishing point – at the very centre of their canvas or sheet of paper. Every line in the work would then meet at that dot, like train tracks receding into the distance, finally appearing to meet in the centre. This creates a convincing effect of depth, even though the vanishing point itself did not literally exist in reality – hence its name.

Foreshortening

Anything depicted using perspective needs to seem to recede into imaginary space. Foreshortening is a technique of imitating the way things appear to the human eye, manipulating the distance or depth of objects and figures in the picture space. For instance, an object will seem larger the nearer it is to the imagined eye of the viewer; a figure lying on its back with its feet towards the viewer will seem to have feet larger than its head. Foreshortening proved a complex challenge for early Renaissance artists; some artists showed off their mastery by foreshortening complex forms and placing them prominently in their paintings.

Cartoon

The word cartoon comes from the Italian *cartone*, meaning a large piece of paper. During the Renaissance, artists across Europe used cartoons as a means of creating large-scale works such as frescoes. Cartoons were made at the same size as the final painting. Drawing in charcoal or chalk, the artist would make a simplified version of the image based on earlier preparatory drawings, and then prick holes through its principal forms. The cartoon was attached to the surface intended to hold the final painting and charcoal rubbed through the holes (a technique called pouncing); the dotted outline left behind when the cartoon was removed became the basis of the painting.

Chiaroscuro

Chiaroscuro is Italian for 'light and dark', but in an art context this term refers to an extreme contrast between the two. This approach is most often associated with the Italian Baroque painter Caravaggio, whose figures often appear to be spotlit against very dark backgrounds. The deliberately heightened and rather artificial effect is intended to control viewers' attention, drawing their eye to certain aspects of the story. There is also an atmospheric quality to this contrast, which lends Caravaggio's paintings an amplified sense of drama that is intended to communicate emotional intensity.

Contrapposto

A contrapposto – literally 'against the pose' – position tends to be unbalanced: a figure stands with its weight on one leg, for instance, instead being spread equally across both legs, as in earlier sculptures. The use of contrapposto in classical Greece made sculpted figures seem more natural and alive, as though they could move. Investing statues with dynamic potential through the straightforward act of altering their position was to have huge significance for the history of sculpture and its relationship to real human bodies.

Printmaking

Despite its marginalization in art history and the art market compared to painting or sculpture, printmaking is often central to an artist's practice. Because of the diversity of techniques available, prints are often the site of an artist's most experimental work. In essence, printmaking involves transferring an image, using ink or paint, from one surface to another, sometimes repeatedly. Making an image by digging into the surface using a tool is known as intaglio printmaking: etching, for example. Other kinds of printmaking include relief printing, such as woodcuts; stencil printing; and monotypes, in which a unique print is created from a plate that has been painted on by an artist.

Casting

Casting metal sculpture requires the making of a mould – which, for thousands of years, could only be used once. The technique for creating a single-use mould, which was used from ancient Greece right up until the late eighteenth century, was known as lost-wax casting. A wax model was built around a plaster core, and then covered in clay; the wax was drained off in hot ovens, creating an empty space into which molten metal could be poured. Once cooled, the clay exterior was chipped away, leaving a coarse metal sculpture that was then chiselled and burnished. Later artists had multi-use moulds, but the finishing process was similar.

Carving

A single block of stone, chunk of wood or piece of ivory might be the basis for a sculpture. Chipping away at this material, using ever-smaller tools, is a reductive process in which the transformation of raw material into a semblance of a figure, for instance, is testament to an artist's skills. For Michelangelo, stone carving meant releasing a figure trapped within the object. In the twentieth century, modernist sculptors sometimes sought to retain some of the surface qualities of the original substance, in a strategy referred to as 'truth to materials'.

Impasto

With the advent of oil paint in the fifteenth century came a whole range of possibilities for painters. Within a century, artists had started to use thick paint in a technique known as impasto; this was not merely a means of depicting something, but was considered a mark of a painter's own expressive capacities. In paintings by Vincent van Gogh, School of London artist Frank Auerbach, and the abstract expressionists, thick paint has an almost sculptural presence. Impasto adds a greater physicality to a painting, asserting its status as an object rather than a representation.

Priming

Priming is the process of preparing a stretched canvas to receive paint using a layer of gesso, a mixture composed of chalk or white pigment with a binder, usually rabbit-skin glue. Unprimed canvas will absorb paint if not prepared in this way, resulting in a stained effect that some artists have used deliberately. American artists of the 1950s expanded the language of painting by using such soaking or staining techniques: Helen Frankenthaler and Morris Louis were particular advocates of this strategy, which created fields of pure colour into which the viewer might feel engulfed, a precursor to the colour field movement.

Pigment

Pigment is colour in its raw state. Before the industrial production of colours in the eighteenth century, painters used natural materials to make paint. Minerals, precious stones, clay, insects, chalk – almost anything could be dried and crushed into a fine powder to make pigment. This powder would then need to be mixed with a binder (egg yolk and water for tempera, walnut or linseed oil for oil paint) and applied to a prepared surface (usually a wooden panel or a canvas). The behaviour of pigments over time varies, given their unusual make-up, and some lose their colour entirely with the passing of time.

Ground

The ground is a crucial, but usually invisible, element in traditional painting. After a canvas has been primed with gesso, the artist will often add a layer of paint before beginning the painting proper. This layer, known as the ground, will have an important effect on the tonality of the colours painted on top of it. A brown or dark red ground will tend to make colours richer and warmer, which is ideal for the candlelit interiors in Rembrandt's paintings. A white ground, by contrast, will lighten the palette by reflecting light, which was a commonplace strategy for impressionist painters, who sought a breezy, airy atmosphere in their paintings.

Scumbling

Scumbling is an effect used in oil painting in which light-coloured paint is applied over an existing dried layer of darker colour in a thin coat that allows the original colour to still show through. Artists use a very dry brush, sometimes one that has stiffened from over-use, with a very small amount of paint to scrub over the area of darker paint. The effect reveals the weave of the canvas below, creating a textured result and a subtle, graded tonality. The English painter John Constable was a particularly good scumbler.

Glazing

Glazing is an oil painting technique that was particularly popular during and after the Renaissance but fell out of favour in the later nineteenth century, possibly because its slowness and delicacy ran counter to the impressionist desire for immediacy and vigour. Glazing involves painting a transparent layer, usually a light pigment thinned down with oil or resin, over a dried layer of paint. The result is a softening of the original colour, a more naturalistic modelled effect and a richer tone. Layers of glazing cannot be applied over still-wet paint, as the perceived colour mixing is an optical rather than physical effect.

Sfumato

Sfumato, meaning 'smoky', is a technique in oil painting that is mostly associated with Leonardo da Vinci, and is used by later artists in imitation of him. Using subtle glazing and a delicate range of tones, Leonardo created a gentle and sensuous modelling effect that does resemble a kind of smokiness. The subtly graded tonality of his depictions of landscape is a good example of the sfumato effect, which eschews the use of line to distinguish forms and instead gradually blends them into each other in a soft transition. Sfumato can create a mysterious and wistful atmosphere in painting.

Gilding

Many medieval works of art and Orthodox Christian icons used gold leaf to create a shimmering, ethereal effect. Wooden panels were prepared with a substance called bole (a kind of sticky red clay), on which the gold leaf was laid in small sheets and gently smoothed down. This gold layer could then be decorated by adding small pieces of plaster, which were themselves given a layer of gold, creating a low-relief effect; the surface could also be pricked with a pin to create patterns, a technique called tooling. The red bole is often visible where gold leaf has worn away.

Patina

Patina is the film that forms on the surface of bronze and copper objects, giving them a distinctive colour – often light green on copper, on bronze a darker greenish-brown. Patination generally happens naturally when a sculpture is placed outdoors and undergoes oxidation through exposure to the elements; it is not dissimilar to rust. Because of the attractive results of natural patination, as well as its ability to protect the underlying object, modern sculptors often create patinas using chemical processes. This artificial patination is not only much quicker to achieve, it can be varied across the surface of a sculpture.

Décollage

Décollage might be thought of as an inversion of collage. Literally meaning 'to unstick', a décollage work of art is started by covering a surface with many layers of found paper, often posters that are covered in text and image. The artist then scrapes away at this surface, tearing strips off to reveal the hidden layers beneath. Décollage works, usually associated with French artists of the 1960s movement known as nouveau réalisme (new realism), seem to mimic the walls of cities, sometimes with political intent, exposing the dominance of popular culture and the capitalist economy.

Imprimatura

Painters sometimes cover the surface of their painting with an initial colour on top of the plain primed canvas; this transparent monochrome layer is known as the imprimatura. It is usually an earthy brown colour like burnt umber, which creates a kind of midtone throughout a painting, allowing the artist to judge the level of dark and light to be applied to the canvas. The imprimatura is often visible in the final painting and provides an insight into the artist's process. It can also help prevent later layers of paint from being absorbed into the ground.

En Plein Air

Painting outdoors – *en plein air*, or 'in the open air' – was a key characteristic of impressionism. Artists believed that completing paintings in the actual scene they were depicting meant that their sensitivity towards that location would be more finely attuned than if they had sketched outside and finished the painting in the studio, as had been conventional previously. Registering the rippling of water or the effects of wind and cloud with loose and spontaneous marks, artists such as Claude Monet, Auguste Renoir and Berthe Morisot were able to create an immediacy and freshness in their work that was initially controversial.

Automatism

Making art without too much intervention from the conscious mind was an avowed aim of the surrealist movement, which was keenly interested in the workings of the unconscious and the truths it might contain. Automatism is the name given to these experiments, which involved all manner of strategies. Max Ernst punched a hole in a paint can and swung it above a canvas, or dropped paint-dipped string from a height. Other artists made drawings collaboratively, randomly, under the influence of whatever they could find. This idea was very influential on the more serious American artists of abstract expressionism in the 1940s.

Palette

The term palette has two related but slightly different meanings: it is both the handheld board used by painters to mix their paints on and a painter's choice of colours in a work. A painting might have a muted, vibrant, limited or decorative palette, for example. A particular range of colours can evoke a certain atmosphere in a work: a muted palette might suggest a melancholy or sinister tone, for example.

Wet-in-wet

Sometimes known as *alla prima* (at first attempt) painting, wet-in-wet painting is just what it sounds like: applying a layer of oil paint directly on top of, or right beside, still-wet paint. While this can result in colours bleeding into each other, the desired effect is of spontaneity and freshness. Painters such as John Singer Sargent and Claude Monet often used this technique, which gave their paintings an atmosphere of immediacy: a sitter in a Sargent portrait might seem more engaged, and rippling water in a Monet landscape would have a sense of movement and liveliness.

Objects
of Art

Assemblage

Assemblage is, in a sense, a three-dimensional version of collage. Artists using assemblage techniques will construct a work of art using found materials, which are often used or damaged. Assemblage dates back to the early twentieth century; it has something of the fragmentary, disrupted quality of cubism, and like that movement can be read as a response to its own troubled social and political context. Assemblage emerged as a kind of alternative to the contained forms of classical sculptural traditions, instead valuing the scattered detritus of modern urban life.

Installation

This is a term usually used in the context of contemporary art, although it has much in common with art of the past. An installation occupies an art space and often requires a visitor's physical engagement to activate its meanings. This rethinking of the viewer as an active participant in a work is characteristic of art produced since the 1960s. An installation is often, but not always, site-specific, and therefore if reinstalled it will elicit different reactions. Installation art is often multimedia and can have a spectacular dimension that seeks to create an overwhelming visual and physical effect.

Altarpiece

An altarpiece is a painting or sculpture designed as the focal point for devotion in a Christian setting. Altarpieces can be situated at the high, or main, altar, or in any number of side chapels that lead off the nave, or central space, of a church. Altarpieces can consist of a single panel or canvas, or a number of joined sections. Church altarpieces tend to be didactic, using content that speaks to a broad audience, but they can also have local touches, such as familiar landscapes or regional saints. Altarpieces for private devotion are generally smaller and can be portable.

Diptych / Triptych / Polyptych

These terms describe altarpieces composed of a number of individual panels: two (diptych), three (triptych), or many (polyptych). Depending on the size of the painting, these panels might be hinged, allowing the altarpiece to be folded up for moving or to reveal paintings on the other side of the panels. A triptych has a central panel to which the outer panels are visually connected, usually through the direction of the gestures or gazes of the characters within it; a diptych might feature a religious image on one side and a portrait of a patron on the other. Polyptychs tend to have one large central panel, with many smaller panels placed around it.

Relief

A relief sculpture is one that stands out from a flat surface. Low-relief sculpture projects only slightly, and sometimes can be very subtly modelled and almost flat, in an effect called *rilievo schiacciato* (squashed relief). This kind of relief acts a little like a painting, and can show depth of space in a similar way. By contrast, high-relief sculpture can project far out from the surface, to the extent that figures seem almost freestanding. Each approach has its own technical challenges and can be carved or cast, or, particularly since the twentieth century, assembled from found materials.

Freestanding

A freestanding sculpture, unlike a relief, exists independently from a surface and often stands on a plinth or pedestal. Often taking a figurative form, a freestanding sculpture is designed to be seen from a wide variety of angles, and artists often consider these points of view as means to create more complex and sophisticated works. Freestanding sculptures are often designed for public places and are sometimes colossal in scale; they frequently represent important leaders, allegorical figures, and notable historical or religious personalities.

Reliquary

A reliquary is a container for a sacred relic, often a body part of a religious figure. Reliquaries sometimes take the shape of the body part they contain, thereby emphasizing the importance of their contents. A reliquary also acts as protection for that relic. The need to be near such objects was a principal rationale for pilgrimages, and reliquaries were often touched or kissed by the faithful. Given that relics are intended to provide physical proof of the veracity of religious narratives, their importance to religious institutions cannot be overstressed, and some churches, temples and chapels themselves can be considered large-scale reliquaries.

Public Art

Public art is found within public spaces, such as city plazas, parks and thoroughfares. It is often site-specific and usually commissioned by the city itself for a number of reasons, including commemorating a person or event, or marking a location of particular significance. It can be ephemeral – a performance, for example – or permanent – such as a sculpture. Public art can often be seen as overt or discreet propaganda for the prevailing political power, but it can also be subversive: graffiti, street art and activist performance are all forms of public art too.

Maquette

A maquette is a three-dimensional sketch. Sculptors usually design small-scale maquettes in order to plan the form of a much larger work. Maquettes can be made of the same material as the final work, but usually they are worked in much looser and more pliable materials: clay and terracotta were often used as maquettes for marble sculptures during the Baroque period, for instance. An artist might also use a maquette to give a patron an idea of the final form of a sculpture, or even as a means of securing a commission from a potential client.

Monumental

The term monument has two different meanings in art. A monument is a structure designed specifically to commemorate a person or persons, or an event, and therefore is deeply symbolic; it can often take the form of an actual building or structure. In this context, 'monumental sculpture' often refers to sculpture relating to monuments in religious buildings, such as tombs. In contemporary art, monumental refers to very large sculpture, often one with a relationship to architectural form.

Colossal

Sometimes something very big is described as colossal, but in art the term specifically refers to a sculpture that is more than twice life-size. Examples of colossal sculpture from the ancient world do still exist, but they are often fragmentary, thanks to shifting political climates in which figures were literally knocked off their pedestals. Hindu and Buddhist figures carved out of cliff faces, such as the Buddhas of Bamyan in Afghanistan and the giant Buddha in Leshan, China, are perhaps the best-known colossal sculptures. Colossal sculpture became popular during the rise of authoritarian regimes in the twentieth century and remains a popular means of expressing the dominance of a political or religious figure across the world.

Pendant

A pendant painting is one half of a pair, which is intended to be displayed together. The origin of the term, which means 'hanging', may refer to the practice of hanging one painting from another, but pendants are often hung side by side or either side of a doorway. Because of this paired form, pendant paintings often depict a married couple, with the male figure generally on the viewer's left, and the female on the right. This is because of associations with Christian art, in which the position on the right-hand side of Christ is taken by the next most important character in the narrative.

Frieze

In classical architecture, a frieze is a strip or band that runs above the columns across the whole length of a building. Friezes can be plain or decorated; usually they were carved with sculpture in relatively high relief and painted, in order to be legible at a distance. Because of their linear, ribbon-like quality, friezes were an ideal means of depicting narrative scenes, which could progress from one part of the building to another: there is often a sense of direction in such forms of frieze sculpture.

Site-specific

As its name suggests, a site-specific work of art relates and responds to a particular location. Examples include a frescoed ceiling, a colossal sculpture, and an installation of sculpture. It might be impossible to move a site-specific work of art from its location, and if it *is* possible, the work could lose much of its meaning in the move. Large-scale sculpture and fresco tends to be site-specific; the artist may have been commissioned to make a work for that particular place, and their decisions – scale, subject, even medium – will likely respond to that place.

Readymade

A readymade is a pre-existing (or already made) object, used by an artist in or *as* a work of art. In this sense, the artist's discovery and usage of that object is the principal artistic act, which gives rise to a synonym for readymade: the found object. Readymade art usually is not altered by the artist, or altered only very slightly. The artist is generally interested in the nature of the transformation that occurs when that object is given a title and placed in a museum or gallery.

Art
Movements

Abstract Expressionism

This term was coined in 1946 to describe a group of mostly New York-based painters (and some sculptors) whose work drew on European modernist art as an influence, especially the spontaneous mark-making of the surrealist artists. Their work is distinguished by its huge scale, which tended to engulf the viewer, obliging them to engage physically as well as visually and intellectually. The diversity of abstract expressionism reflected both the artists' deeply personal work and the culture of individualism in a triumphant post-war America. This is reflected in the range of strategies associated with it – from Mark Rothko's sombre fields of rich colour to Jackson Pollock's flicks and drips of paint.

Cubism

Since the Italian Renaissance, single-point perspective was considered the most accurate way of depicting space; cubism, around 400 years later, was the first movement to seriously challenge that way of thinking, attempting to reflect how we truly see the world – as a series of glimpses as we move through space. Though taking as its subject the humblest of things – bottles of wine, bread, tables, newspapers – cubism was seismic in its effects. Georges Braque and Pablo Picasso's cubist paintings, sculptures and drawings presented a fragmentary notion of human vision that transformed the relationship of visual art and human reality.

Dada

No one has ever agreed on what Dada actually means, which is appropriate for the world's first truly anti-art movement. Dada was a loose group of performers, poets and artists who first coalesced in Zurich during World War One. Responding to the terror and confusion of the war, these artists deliberately embraced a nonsensical, sometimes random approach to making works of art. Dada had no one geographic centre. Berlin, Cologne, Paris and New York Dada are all very different, but are united by a subversive spirit and a desire to overturn all received notions of quality and authenticity in visual art.

Fauvism

Fauvism takes its name from a bad review, in which a classical-style sculpture installed in a room of contemporary paintings in 1905 was described as 'Donatello chez les fauves' (Donatello among the wild animals). The term refers to the work of a handful of early-twentieth-century painters known as les Fauves, especially Henri Matisse, André Derain, Maurice de Vlaminck and Georges Braque. Their paintings are characterized by blistering colour palettes that reflect the blazing sunlight of the south of France, where they were mostly made, along with a radical rejection of mimetic colour and a dynamic looseness in brushwork. Fauvism did not last long in any of the artists' careers, but the style was to prove influential for many years to come.

Impressionism

In 1874, art critic Louis Leroy wrote about a painting by Claude Monet entitled *Impression, Sunrise*. Leroy wrote that the work was indeed just an impression, and not a finished painting. The artists involved in the exhibition – including Auguste Renoir, Paul Cézanne and Camille Pissarro – did not embrace the term impressionism, but it stuck. Leroy's critique reflected conventional taste at the time for much more finished-looking history paintings. Impressionist brushwork is fragmented, often evoking the movement of light on water or the drifting of smoke, as though the immediate effect (or impression) of a scene were the painting's real subject.

Pop Art

A truly global phenomenon, pop art represented a moment in which artists engaged with popular culture of all varieties, from mainstream cinema to pop music to mass-produced products and celebrities. Far from a straightforward celebration of popular taste, pop art took a sometimes cynical and often ironic approach to this new content. Because it was produced in so many different places, there is no one single idea of 'pop art' that holds true universally. A common thread in the movement is that pop artists tended to be drawn to images mediated through advertising, television, cinema and celebrity culture.

Minimalism

The best definition of minimal art comes from one of the best-known minimal artists, Dan Flavin: 'It is what it is, and it ain't nothing else.' He was referring to his own work, which consisted of nothing more than fluorescent strip lights and the light they cast in a gallery space. Works by other minimalist artists were similarly blunt and direct in their physicality. Minimalism's refusal to allow sculpture to act as a metaphor for something else – a body, an individual, a landscape – meant that the live experience of the work became central to its meaning.

Post-minimalism

Responding in part to the austerity of minimalism, post-minimalist artists returned bodily metaphor to modern sculpture. Rather than plywood, aluminium and lead, post-minimalists used latex, felt and foam. Their materials sagged and slumped or flopped on the floor. The fundamental principle that these two movements were founded on – to place sculpture in the space of the viewer's body, to be engaged with directly, rather than on a pedestal, to be looked up at – has had a profound impact on contemporary art.

Conceptual Art

Art has always been about the expression of ideas, but in the second half of the twentieth century certain artists believed that the idea should take precedence over the expression. Art as pure idea naturally has a lot in common with philosophy, but conceptual artworks are generally shown or staged within galleries or art spaces, and consequently have a visual element too. Some works of conceptual art exist simply as ideas thought up by an artist and then executed by someone else. It is not just the idea of the artist that is significant in conceptual art, it is the intellectual engagement of the viewer, too.

Photorealism

Photorealist painting attempts to capture the visual world with the accuracy of a camera's eye, and often mimics the depth of field and lens flare found in its photographic source material. Emerging in the 1960s, largely in the United States, photorealism, unlike a photograph, is made incredibly slowly, often by projecting a photograph onto a canvas as a guide. It is the tension between the quickly made original image and its slow reproduction that makes such paintings compelling. In early photorealism, this precision gave its often banal subject matter a strange intensity that can tip towards the surreal.

Land Art

Certain artists of the 1960s and 70s expressed their dissatisfaction with the increasingly commercial pressures of working in the art world by finding ways of making that evaded this culture. Land art was born of this attitude: artists made sculptural interventions in the landscape, often in sites that were deliberately far from conventional art centres. Making the pilgrimage to see a work of land art was part of the point, as the visual noise of the urban landscape, and the tendency for works of art to be judged in relation to others, was shorn away, creating, ideally, a pure and unmediated experience of art in nature.

Performance Art

Over the last century at least, artists have been using performance as part of their practice, but it is really only since the 1960s that it has solidified as a medium in its own right. In distinction to most theatre, performance art tends to take place on a physical level with the audience, can often be very long, and eschews theatrical effects for more direct communication. This interest in immediacy led to a lot of nudity in early performance art, as well as some confrontational and sometimes disturbing activities, captured on grainy video or sometimes restaged as a means of generating new interest in the approach.

Kinetic Art

As its name suggests, kinetic art is based on movement. This might be induced by a motor or made by the interaction of a viewer or the natural movement of air and wind. Modernists such as Russian artist Naum Gabo and American Alexander Calder made sculptures that moved and therefore changed their form; Gabo's work included mechanical parts, Calder's hung from the ceiling in the form of a mobile. Calder's work depended upon the bodily movement of viewers, which would cause the mobile to transform its shape accordingly. Allowing sculpture to move disrupted the traditional stability and solidity of the art form.

Op Art

Op art, short for optical art, had a particular interest in unusual optical effects. Emerging in the 1960s, op art often used monochrome palettes or vivid colours in order to make flat works of art appear to be moving, or to create powerful chromatic results. Artists associated with this movement, including the British artist Bridget Riley, Hungarian-French Victor Vasarely and Venezuelan Jesús Rafael Soto, were steeped in theories surrounding the psychology of perception, which influenced their intent to create such effects in their work. Soto also used kinetic elements in his work, such as mobiles, which enhanced these qualities.

School of London

This term refers not to a school per se, but to a loose group of painters based in London in the years following World War Two. These artists all focused on the representation of the human body, which in their works was often contorted, abstracted and somewhat anguished, perhaps in response to the traumas of war and its aftermath. The term was coined in 1976 by the American painter R.B. Kitaj, who was himself associated with the group. Other artists associated with the School of London include Francis Bacon, Lucian Freud, Frank Auerbach, Michael Andrews and Leon Kossoff.

Metaphysical Art

This term is used to describe paintings made by Italian artists, particularly Carlo Carrà and Giorgio de Chirico, from around 1911 until the 1920s. Metaphysical art is characterized by a simple, almost deadpan naturalism, which uses traditional single-point perspective and often includes allusions to the classical or Renaissance past, though it is far from backwards looking. Metaphysical art has an uncanny quality through its use of displaced ordinary objects and melancholy settings of empty town squares and distant steam trains. Such effects endeared these artists to the later surrealists, who claimed them as forerunners, partly correctly.

De Stijl

De Stijl, simply meaning 'the style', was a Dutch avant-garde art and design movement formed in 1917, taking its name from the title of a journal founded by Theo van Doesburg. Artists and designers associated with De Stijl include Piet Mondrian and Gerrit Rietveld. The visual language of De Stijl values a simple and harmonious relationship between colour and line, without ornamentation or pattern. Generally, the De Stijl aesthetic uses flatly applied primary colours separated by thick black lines, which can be seen most characteristically in the architecture and furniture of Rietveld and the paintings of Mondrian, who also used the term neo-plasticism to describe his De Stijl paintings.

Constructivism

Constructivist works of art borrow from the language of industry, often using scrap metal to create three-dimensional assemblages that might hang on the wall like paintings. Formed in revolutionary Russia around 1917, constructivism sought to recast the artist as blue-collar worker. Led by Vladimir Tatlin, the constructivists saw art as an extension of revolutionary politics, rejecting the emotional expressiveness of traditional painting in favour of an art that spoke of collective action and the mobilization of the working classes. The movement was short-lived in Russia but became popularized in the West thanks to émigré artists Naum Gabo and Antoine Pevsner.

Neue Sachlichkeit

Sometimes translated as 'new objectivity', this term refers to German artists who worked between the world wars in a realist style that was quite different to the radical modernism of the previous decades. Though not a movement as such – the artists associated with it worked in various parts of Germany – Neue Sachlichkeit refers to a distinct tendency in interwar German art to return to traditional painting techniques and the subject of the figure. However, there was nothing conservative about these bitter, sometimes shocking works of art, which often lacerated the Weimar culture of the time.

Retour à l'Ordre

Many European artists after World War One rejected the avant-garde techniques that had characterized the art before it, and instead revived the realist strategies of the Renaissance tradition. Even such radical artists as Pablo Picasso, André Derain and Georges Braque turned to traditional painting techniques and subjects during this period. The motivation for this unexpected U-turn was in large part the trauma of war itself, which inspired a revival of more reassuring artistic approaches. Despite this, retour à l'ordre (return to order) works often retain an unsettling quality, and can be satirical, as in the German Neue Sachlichkeit artists George Grosz and Otto Dix.

Symbolism

Symbolism was a French movement in art and literature towards the end of the nineteenth century that, to some extent, prefigured surrealism in its interest in the subconscious and the depiction of the dream state. Symbolist artists rejected a realist approach to the depiction of human life, using instead symbolic content to allude to subjective experiences. This lent their art an often dreamy, mystical and erotic quality, as seen in the work of Odilon Redon, Gustave Moreau and Ferdinand Hodler, which could be nightmarish and grotesque, too. Symbolism is related to romanticism, especially the Gothic strain.

Suprematism

Suprematism and constructivism were two Russian avant-garde movements that sought to embody radical politics within a reduced geometric visual language. Suprematism, led by Kazimir Malevich, was the more reductive of the two; its most infamous example is Malevich's *Black Square* from 1915, which strips painting down to the essential relationship of contrasting tones. This kind of radical simplification of painting's formal elements was, for Malevich, parallel to the revolutionary politics that led to the Bolshevik Revolution of 1917. Liberating painting from recognizable content allowed the viewer to interpret the work more freely, collapsing hierarchies of art historical knowledge.

Post-internet Art

Post-internet here refers to artistic practices that reflect upon the influence and role of the internet in contemporary society. This does not necessarily mean works of art made to be experienced via the internet (that would be more commonly called net art); post-internet art can easily manifest as painting or sculpture. How we experience human interaction, convey political inclinations or understand sexuality, as well as how we experience and engage with images in an age of mass reproduction and dissemination, are central preoccupations of this strand of contemporary art.

Arte Povera

Arte povera, which literally translates as 'poor art', was a movement in 1960s Italy that made use of a wide range of materials not traditionally associated with fine art. Arte povera artists used found materials that often related to an agrarian culture, in stark contrast with the more urban aesthetic of their American contemporaries. Straw, hay, old clothing, soil, lettuce, even live animals – the materials of arte povera work were intentionally ephemeral, unconventional and anachronistic. Artists associated with this movement were dedicated to dismantling the boundaries between the made and the found, the valuable and the throwaway, the artificial and the natural.

Gutai

The artists associated with the Japanese post-war art movement Gutai were principally based in Osaka. As early as the mid-1950s, Gutai artists were using performance in their work in radical ways as part of their dedication to absolute freedom of expression. One artist, Kazuo Shiraga, placed a canvas on the floor and hung above it from a rope, then pushed paint across the canvas using his bare feet. This interest in the physical trace of the artist's body is reflected in the common translation of *Gutai* as 'embodiment' or 'the concrete'.

Pre-Raphaelites

The Pre-Raphaelites were a group of British artists in mid- to late-nineteenth-century London who were united in their dislike of the traditionalist Royal Academy, which venerated the works of Renaissance artist Raphael as the summit of artistic achievement. As their name suggests, the Pre-Raphaelites sought to return art to a time before the High Renaissance, and found their inspiration in medieval art and literature, as well as the art of the early Renaissance. Consequently, the style of their art was often characterized by clean, precise lines, an interest in organic forms, and an emotional restraint. Often associated with poets, Pre-Raphaelite artists sometimes derived their subjects from literature, especially that of the past.

Fluxus

Fluxus was an international avant-garde group of artists and composers whose name means 'flowing' or 'changing'. From the early 1960s to the late 1970s, their dedication to collapsing the barriers between art and life proved highly influential in contemporary art. Fluxus happenings, which generally relied on audience participation, fused the nonsensical with the politically engaged. Despite their wide geographic reach – there were Fluxus activities in the United States, Japan and Germany – Fluxus artists were united in a spirit of anti-academic liberation. Inspired by the composer John Cage, many of them used chance and humour to generate new ways of making and engaging with works of art.

School of Paris

Though not officially a school, this term refers to a loose group of artists, poets and composers who lived and worked in Paris in the early years of the twentieth century. Areas such as Montmartre and Montparnasse became centres of artistic practice and social life, making them crucibles of creative thought. Many artists associated with the group travelled to Paris from other countries, drawn to the city's artistically and politically liberated atmosphere. Following its fall to the Nazis in 1940, Paris no longer held the dominant cultural position it had before. It is often said, somewhat accurately, that New York claimed that place after the war.

Mono-ha

Mono-ha, usually translated as 'school of things', was a movement in mid-1960s Japanese and Korean art that valued the dialogue between organic and artificial materials, which were treated simply and placed in subtle and sensitive installations. Mono-ha works of art used natural objects like rocks, soil and water, often juxtaposed with sheets of steel or glass. The effect is minimal in aesthetic and contemplative in tone. These were works that stood apart from the international art market: mono-ha works were often ephemeral and depended on the viewer's experience with the objects in space.

Bauhaus

The Bauhaus was one of the most celebrated and influential art schools in history. Based in a number of German cities – Weimar, then Dessau, then Berlin – the Bauhaus took a radical approach to art education, fusing fine art with crafts, design and architecture. Its aesthetic was generally stripped-down, geometric and industrial. The Bauhaus was founded between the two world wars and was finally shut down by the Nazis in 1933, whereupon many of its most influential members fled to other countries, where their influence spread. Perhaps most notable is its influence in the United States, where Bauhaus émigrés permanently transformed American architecture.

Art Styles

Abstraction

In Western art, the idea of abstraction is relatively young – little more than a century old – although it is much older on a global scale. An abstract work of art makes no reference to the visual world, a strategy that has been used to achieve hugely diverse effects: to evoke visionary spiritual states (Hilma af Klint), to suggest the qualities of music (Wassily Kandinsky), to announce a new political order (Kazimir Malevich) and to capture the vibrancy of modern urban life (Sonia Delaunay). Later painters used abstraction to speak of timeless philosophical truths (Mark Rothko) and to explore the expressive potential of paint itself (Kazuo Shiraga).

History Painting

The term history painting refers to large-scale paintings that took as their subject matter narratives from history, classical mythology and the Bible. These diverse subjects were united in a common approach: multi-figure stories, often with dramatic content, frequently made as an attempt to elevate or entertain the viewing public. Often didactic, sometimes using allegory to endorse a contemporary political situation, history paintings spoke to a general public that flocked to exhibitions at the academies in London and Paris in the nineteenth century. History painting, in part by virtue of the size of its canvases, dominated such exhibitions.

Classicism

Classicism is much more than a style: it brings with it a complex set of associations and meanings, and our experience of it is often filtered through later appropriations of the original classical aesthetic. The grandeur of ancient Greek temples generates an effect of permanence and power, and its association with intellectual innovations in philosophy, literature and science meant that it became a coded expression of these ideals when used in later contexts. Classical revivals started in ancient Rome and continued, in various ways, throughout medieval and Renaissance Europe and into the classical revival, known as neoclassicism, in the eighteenth and nineteenth centuries.

Expressionism

This style had its beginning in German expressionism, an umbrella term used to refer to two art movements in Germany in the early twentieth century: Die Brücke (the bridge), based in Dresden and Berlin, and Der Blaue Reiter (the blue rider), based mostly in Munich. Although these were very different movements in terms of their works' content, they had certain similarities – an interest in bold, sometimes clashing colours and a slashing, powerful approach to mark-making. With a particular interest in psychological intensity and its reflection in dramatic colours and energetic strokes of the brush, expressionism as a strategy remains current.

Baroque

Between the seventeenth and late eighteenth centuries, European art and architecture underwent a flourishing of the arts known as the Baroque. Flamboyant churches emerged, along with exaggeratedly dynamic sculptures and paintings featuring a heightened sense of drama. In essence, the Baroque sought to engage viewers by appealing to their emotions above their intellect. Baroque art is often viscerally graphic and shocking, or lavishly ornate, as an attempt to dumbfound or overwhelm its viewers. Usually associated with Catholicism and absolute monarchies, Baroque art was an often didactic expression of power that intended to speak directly to its audience and to grip them utterly.

Gothic

The word Gothic refers to a wide range of cultural products, including architecture, painting, sculpture and the decorative arts. The Gothic dominated the European Middle Ages. Its misleading name described the art of the Goths, a Germanic tribe, but the Gothic style is found across Europe, hence its occasional (also misleading) synonym International Gothic. An art based upon organic forms, the Gothic is characterized by flowing, curved lines, complex patterning and decorative surfaces. When revived in the nineteenth century, Gothic's aesthetic was read as a natural counterpart to the rise of industry.

Renaissance

Literally meaning 'rebirth', the term Renaissance refers to a modern interpretation of antique forms, mostly in Italy, and a revival of interest in the artist as an independent creative spirit rather than a craftsman. Patrons supported artists to create ever more innovative works of art, and artists began to be known by name and sought after across Europe. The Renaissance opened the door for later experimentation by rethinking the role of the artist in society, and by reframing works of art as not simply didactic instruments for political or ecclesiastical power but as conceptual products in their own right.

Rococo

Like many terms in the history of art, rococo was used as an insult by later historians. The word is associated with whimsical decorative arts and used to describe paintings, sculpture and architecture of the mid- to late eighteenth century. Rococo art is characterized by its airiness and sensuality and is, in a way, a variation on the Baroque, with its darker content expunged. It was generally found in a courtly setting, where its unchallenging content and self-conscious hedonism would have met with appreciation. After the French Revolution, such a style perhaps inevitably fell out of favour, but contemporary painters have been reviving it in recent years.

Monochrome

A monochrome work of art is made in a single colour. This can be as extreme as an all-white canvas, such as were made by a range of artists in the twentieth century. *Grisaille* paintings range from dark grey to white (*gris* is 'grey' in French); they became popular in northern Europe during the Renaissance. The effect of monochrome painting can be to call attention to the fiction of art itself, making a painting seem like stone, or it can be a means of considering formal qualities of the work, without making any associations with the world beyond.

Caravaggism

The short-lived Italian Baroque painter Caravaggio left behind a relatively small body of work, but it made a huge impression both on his contemporaries and artists of the following generation. Caravaggism is a term that alludes to this influence and its various manifestations. Caravaggio's use of dramatic chiaroscuro, theatrical storytelling and naturalistic physiognomies rippled outwards from Italy and inspired artists as far afield as Spain and Holland. Rembrandt, who never travelled out of Holland, absorbed this influence through his teacher, Pieter Lastman; Diego Velázquez may have encountered it at second hand too.

Pointillism

Impressionist-style paintings made entirely with dots of paint are done in the pointillist style, a technique developed by French artists Georges Seurat and Paul Signac in the 1880s. Seurat and Signac's interest in scientific theories of colour led them to experiment with placing two dots of different colours next to each other; at a distance, the juxtaposition created the optical effect of new colours. These were often complementary colours, and so created a brilliant vibrancy in the painting that captured certain effects of light and atmosphere. The term was, as with many other modernist 'isms', first used as an insult.

Mannerism

Mannerism is a term conventionally used to describe a moment in the history of Renaissance art in the sixteenth century at which a certain kind of self-conscious affectation crept into art. Artists made allusions to other artworks, deliberately contorted represented bodies, and used heightened, wilfully artificial colour schemes. Mannerism seems to have occurred in many European countries and is usually associated with private, courtly art, where its complex references might have come across as witty. A taste for the bizarre, the erotic and the grotesque characterized Mannerist art; much of this was swept aside in the aftermath of the Protestant Reformation, never to return.

Art Nouveau

This late-nineteenth-century movement in art and design flourished in many countries, including France, Britain, Spain, Austria and even the United States and Japan. Their diverse approaches to the movement were founded on an interest in organic forms, flowing, sinuous lines and, especially, a collapse in traditional distinctions between fine and applied arts. Art nouveau artists often worked across media, designing posters, furniture, stained glass and clothing as well as paintings and sculptures. Its rejection of academic traditions and reframing of the artist's relationship to popular culture was influential well into the twentieth century.

Secession

Secession literally means the withdrawal of a group from a larger body. In the history of art, a number of artist groups withdrew from official (often state-run) institutions and formed their own organizations, sometimes with a permanent venue in which they could show their work outside the strictures of mainstream taste. Perhaps the best-known of these movements was the Vienna Secession, which had its own dedicated building in which artists and designers such as Gustav Klimt and Josef Hoffmann could showcase their unconventional works of art and design. The secession is an archetypal model of the modernist relationship between art and the establishment.

Outsider Art

This complex and problematic term is used to refer to works of art made by those who exist outside of the conventional structures of the art world (untrained artists, for example), or who make art without awareness of audience (such as children or the mentally ill). Outsider art, sometimes also called naïve art or art brut (raw art), tends to be valued for its immediacy, its lack of self-awareness and its direct means of expression. Modernist artists became fascinated by such work and often sought to mimic its qualities in their work; this kind of art might be called faux-naïve.

Propaganda

Though not always taking visual form, propaganda is perhaps most effective when it does. Propaganda is a form of didactic art that exists to influence its viewer towards a certain course of action: supporting or denouncing a political leader, for example. Central to effective propaganda is public visibility. This might mean art made on a large scale in a public place, or art made to be reproduced and widely disseminated, in the form of a pamphlet, film, news story, or online activity, for example. Propaganda thrives on directness, emotional manipulation, clarity of form and ease of distribution.

Kitsch

Kitsch is such a commonly used word that defining it is a little problematic. Anything in bad taste, vulgar or outmoded is often called kitsch; this is, of course, dependent on the speaker's own social context, since the term is used to mark the limits of acceptable taste. Generally kitsch is associated with popular taste and is often related to mass production, as opposed to a fine art tradition, which is elite and unique or produced in limited editions. Artists of the 1960s engaged with kitsch culture, but always through the lens of fine art, resulting in works that generated productive friction between two opposing ideas of quality.

Street Art

Using public space as a canvas on which to express political dissent or personal animus, or simply to announce your existence, has an ancient history, but the term street art is a relatively recent invention. Street art emerges out of mid-1970s American urban graffiti culture, which focused primarily on text or images sprayed using aerosols. Street art, by contrast, can include a vast array of different approaches, including stencils, projected light and video, and even sculpture. Street art is often politically engaged and critical of prevailing power, but it is just as often not.

Art Deco

Art deco is a style found in architecture, design and fine art of the 1920s and 30s. It can be seen in part as a reaction against art nouveau's sinuous and ornamental aesthetic, which it mostly rejected in favour of a more geometric, industrial-inspired style. Art deco fused a wide range of influences, including cubism, ancient Aztec and Egyptian art, and industrial design, especially trains, boats and cars. Art deco was a fairly short-lived style, associated with the economic boom of the 1920s, and faded from fashion during the depths of the Depression and the onset of war in the 1930s.

Cave Paintings

Cave paintings are the earliest known form of painting and are generally prehistoric (around 40,000 years old). They are usually thought to have been made by modern humans (*Homo sapiens*), although there is some evidence of Neanderthal art too. Because of their locations, cave paintings can be well preserved, despite their age. Painted or drawn onto cave walls using red (iron oxide) or black (charcoal) pigments and fingers or simple tools, these images tend to replicate something seen in the natural world, usually animal behaviour; humans are rarely depicted. There is no consensus on their function, which is one of the many reasons why they seem so modern.

Contemporary Art

Though ostensibly a simple phrase meaning 'the art of today', the term contemporary art is much more complex. It is not quite accurate to describe all art made in the present as contemporary art, as it tends to be defined by institutions that are required to make value judgements about the quality and currency of living artists, including museums, galleries and auction houses. Generally, contemporary art is associated with a postmodern climate of geographic diversity and neoliberal politics and is characterized by a cross-pollination of media and modes of working. Like modernism, from which it draws much of its energy, contemporary art is determinedly new and avant-garde in intent.

Modernism

Within the arts, modernism tends to refer to a period just at the turn of the twentieth century in which artists from a wide variety of countries embraced the notion of art as experimental, challenging and expressive. Fuelled in part by the boom in urban living with its associated technological innovations, modernism embraced the new, but was critical of it, too. A belief in art's need to be novel, as well as its potential for shaking audiences out of their complacencies, meant that much modernist art deliberately set out to disrupt the conventions of whatever medium it found expression in.

Postmodernism

Postmodernism is built upon and responds to many of the central tenets of modernism. Where modernist artworks tended to prize personal expression, a restless pursuit of the new and an experimental approach to the medium, postmodernist works seemed content to recycle, often with an ironic approach, existing visual material, from the old masters to popular culture. Postmodernism often sought to blur such distinctions in any case. The implication is that postmodern culture is built upon ruins, in which the old certainties of (especially) Western culture were subject to critique and even parody.

Primitivism

Rarely used without quotation marks, 'primitivism' refers to a sensibility in late-nineteenth- and early-twentieth-century Western European arts that moved away from native traditions and towards the aesthetics of non-Western cultures. Artists such as Georges Braque, Pablo Picasso and Henri Matisse encountered African and Oceanic objects in Paris collections, largely composed of colonial booty. Seeking a clean break from the classical tradition that dominated academic art practice, they absorbed the influence of these objects, translating them into a raw and immediate aesthetic that was highly influential, though not based on any actual knowledge of the objects themselves.

Romanticism

Romanticism encompasses a huge variety of cultural forms in the early nineteenth century. In European art, the romantic spirit finds expression in the dramatic, the emotionally charged, the Gothic, the exotic and the erotic – anything, in short, that runs counter to the empirical, the logical and the ordered. J.M.W. Turner, Caspar David Friedrich and Eugène Delacroix made paintings that epitomized this position. Romantic artists, accordingly, positioned themselves as outsiders, whose subjective experiences found expression in dynamic, surging works of art, often charged with melancholy, wistfulness and yearning. Romanticism's interest in these personal expressions opened the door for modernism in the twentieth century.

Old Master

Old master is a term often used to describe works of art made in Western Europe between 1400 and 1800 in the tradition of the Italian Renaissance, and is often used in the art market to refer to a sale of artworks from that period. The term suggests a certain standard of quality and a relationship to a tradition of virtuosity, naturalism and illusionism. Its problematic name and historical vagueness has been criticized in art history and is no longer used, though it is retained in a commercial context.

Academic

In art history, academic is a term connected to the art academies that were founded in Paris and London in the eighteenth century. The training within these academies, which was closely based on the art education of the previous epoch, was rigorous and highly disciplined, based on drawing from antique statuary and life models. Students would go on to create naturalistic history paintings, which by the late nineteenth century seemed conservative and backward-looking. From that moment, the term became pejorative and is still used to describe conservative forms of artistic expression.

Realism

In art history, the term realism is generally used to refer to a specific moment in the history of Western art at the very beginning of modernism. French artists such as Gustave Courbet, Jean-François Millet and Jean-Baptiste-Camille Corot made paintings that epitomized realism's interest in scenes of everyday life, which eschewed the grand heroism of traditional history painting. Inspired by the rise of socialist thought and the conditions of the workers during the Industrial Revolution, realist artists sought a clean break from romanticism, focusing their attention on the plight of the poor and the unheroic realities of working-class life. The term is often used interchangeably with naturalism.

Orientalism

Orientalist art is characterized by depictions of settings that are alien to the artist's own context. French and British artists in the nineteenth century, for instance, would depict North African or Middle Eastern harems and market squares in their paintings, which were aimed to satisfy a popular taste for the exotic among art collectors. Depictions of distant lands provided the opportunity for erotic scenes that would have been impossibly indecorous otherwise. Orientalism concocted fantasy portrayals of countries that were usually under the colonial control of the artists' own, places as diverse as Turkey, Egypt, India and Algeria.

Japonisme

Japonisme can be considered a subset of orientalism. As its name implies, it refers to a craze for Japanese art and culture among Western artists, which emerged in nineteenth-century Western Europe thanks in part to the resumption of Western trade with Japan after 1850. The influence of Japanese art, especially printmaking, on Western painting, sculpture and design was enormous. The flattened perspectives, sinuous lines and cropped compositions of Japanese art are evident in impressionist painting, art nouveau design and secessionist printmaking, among many other styles and forms of art.

Institutional Critique

Since the 1960s, artists have cast a critical eye on the institutions that constitute the art world, and have made work designed to expose their sometimes dark underbellies. A well-known example is American artist Fred Wilson's work *Mining the Museum* in 1992, for which he reinstalled the collection of the Maryland Historical Society. Objects not usually on display were juxtaposed with objects from the permanent collection: slave manacles were displayed next to fine pewter jugs, for instance. Even a museum's architecture can be subject to investigation by artists interested in the narratives of power expressed by the institution.

Happening

Happenings were events staged by artists in the 1950s and 60s that preceded performance art, but shared some of its qualities. Predominantly associated with American artist Allan Kaprow, happenings were interactive live events in an environment that had often been transformed into a temporary installation using lights and sound. Often improvisatory and without formal structure, happenings were deliberately open-ended and participatory. Where performance art focused on the artist and their body, happenings were much more audience-led. Happenings do still occur within contemporary art, but the term itself is tied to its historical and countercultural origin.

Textiles

Although weaving and embroidery have been central to global culture for thousands of years, they and other textile arts were only embraced as a medium in Western art in the later twentieth century. One reason for this belated acceptance is the identification of textiles with craft as distinct from fine art, a division that emerged in the Renaissance to separate artists from artisans. Traditionally male-dominated art history relegated textiles as domestic 'women's work', but it was this very marginalization that drew feminist artists to it in the 1960s and 70s. The physicality of textiles might also account for their revival in an age of the digital and virtual.

Art
Concepts

Appropriation

Appropriation is the art of theft. Appropriation artists emerged in New York in the late 1970s, and used existing images – from cinema, television, newspapers, advertising, even other artists' work – to investigate hidden meanings within that source material. By creating images of images, appropriation artists shone a critical light on one of the abiding principles of Western art history – that an artist must always be original – and questioned that assumption. Far from being a cynical prank, the work of American artists Sherrie Levine, Sarah Charlesworth and Richard Prince, among others, is a melancholy recognition of the dislocation our contemporary, image-swamped culture can produce.

Uncanny

Sigmund Freud used the term *unheimlich* (literally meaning 'unhomely') to describe something familiar that has become disturbing, such as an inanimate object that suddenly moves, or one's own double. In English, *unheimlich* is usually translated as 'the uncanny'. The suggestion is that of a repressed and perhaps taboo desire, which finds expression in the uncanny object. Surrealist artists such as Salvador Dalí and Man Ray took conventional objects such as telephones and irons and gave them an uncanny quality through the addition of unexpected elements: a lobster (Dalí's *Lobster Telephone*) and a row of nails (Man Ray's *Gift*).

Sublime

The sublime, a notion first discussed by Anglo-Irish philosopher Edmund Burke in the mid-1700s, is a complex term that has fired the imaginations of artists since that time. Put simply, the term refers to a human experience that goes far beyond the conventional: it might be an awe-inspiring, startling, overwhelming or even frightening moment. For Burke and thinkers of the romantic period, such experiences might be found in the contemplation of the vast scale and power of nature, such as facing a roaring waterfall, or gazing down from a high peak. In such moments, the human subject might feel insignificantly small and have a poignant sense of their own mortality.

Serialism

Serialism – not an art movement, but an idea in modern art that runs across media and techniques – is a strategy of repetition often found in minimalism. A single formal device, like an object of specific dimensions, might be repeated many times, with some minor variations, or perhaps no variations at all. Serialism rejects the idea of a hierarchy of parts, preferring instead an equal repetition of the same elements. The effect of serialism, as seen in the thirty-two near-identical paintings in Andy Warhol's *Campbell's Soup Cans*, can have a numbing effect, and is deliberately inexpressive and even mute.

Didactic

Didactic works of art are designed with a single aim in mind: to instruct the viewer. Such works are perhaps unsurprisingly associated with church interiors, where paintings and sculptures were placed in such a way as to speak directly to their largely illiterate audience about the fundamentals of the Christian faith. All religions have didactic art, however, as visual art can communicate with an immediacy that the written or spoken word cannot. Visual clarity and consistency is paramount in didactic art, even that in a non-religious context, such as depictions of political figures or heads of state.

Discourse

Contemporary art is often mocked, usually accurately, for its cavalier approach to the English language. The word discourse has become a cliché in both contemporary art writing and the criticism of it, but in this case the term is both useful and not easily replaced with other words. Discourse refers to the sum of conversation around an idea that might provide a useful intellectual context for understanding works of art. Discourse is a culture of analysis, theorizing and critique in a particular historical period; you might talk about 'the discourse of romanticism', for example, as a way of contextualizing a work of art produced in the late eighteenth or early nineteenth century.

Picturesque

Literally meaning 'like a picture', the term picturesque became popular in the eighteenth century, and was used to describe certain qualities of real landscapes. It is particularly associated with classically inspired, elegantly constructed scenes of seventeenth-century French landscape painter Claude Lorrain. Landscape gardening of the time followed suit. The term retains a currency in contemporary usage, where it is used as a synonym for beautiful, but it may also describe a kind of art-like order and composition evident in the real place being described.

Marxist Theory

A Marxist analysis of a work of art investigates the means of its original production and its relationship to the economic structure of its time, in line with the writings of German philosopher Karl Marx and other similar theorists. This approach to thinking about works of art has been hugely influential, even if not always flagged as Marxist. A Marxist interpretation of Western art history, for instance, might address the class conditions of artists and their relationship to the history of capitalism. Such interpretations have opened up new ways of thinking about art history and have been influential on artistic practice itself.

Feminist Theory

Feminist art theory analyses the gendered assumptions of conventional art history, in which men have traditionally taken centre stage as producers and consumers of works of art. Feminist theory investigates the power structures that have created exclusions within art and its institutions. The analysis of the representation of women is also a central part of feminist art historical work. These theories have been highly influential in artistic and academic practice, and often within museum collecting strategies and exhibition programming. But this work is by no means done, and feminist thinking retains its currency and urgency today.

Freudian Theory

Psychoanalytic theories of art, which emerge from and sometimes critique the writings of Austrian neurologist Sigmund Freud, investigate the expression of the unconscious mind in art. Works of art can unintentionally express otherwise suppressed or sublimated desires, and psychoanalytic theory aims to locate and dissect these hidden meanings. Theorists after Freud pushed this kind of analysis further, unearthing the ideological basis of many of our unconscious assumptions. This kind of investigation generated new freedoms in academic thinking about art, in which the ostensible subject matter or form of a work of art might be looked through to excavate its inner workings.

Postcolonial Theory

Postcolonial theory addresses structures of exclusion in the context of the Western colonial period (c.1500–1950), and how those structures continue to assert an influence today. A primary focus in postcolonial theory is the experience of the oppressed individual, and the expression of that experience in works of art. Postcolonial art history may well examine the representation of non-Western cultures in Western art, and unpick the assumptions that underlie that representation. Artists from former colonies may make works that assess their relationship to a dominant culture from a position of critique. These theories are now part of a broader discussion of race, gender and power.

Canon

The canon, which is a term used across the arts, refers to a group of practitioners considered the greatest in their field. The canon of art history is by no means fixed; artists from across history are being added to the canon regularly. The canon manifests itself primarily in museum collections and exhibition programming, which in turn influences the art market, the syllabi of taught art history courses, the publication of books and the production of television programmes. Despite a long history of questioning the validity of the canon's exclusionary construction, it remains central to many people's experience of works of art.

Mimesis

Mimesis is a Greek term used in the study of art as well as literature, and refers to an art of imitation, a little like a reflection in a mirror. Mimetic art is that which attempts to accurately represent human existence; in art, this might be expressed as a kind of realism or naturalism. The term has been used to belittle representational art, suggesting that mere imitation of nature suggests a lack of creativity, hence the term *mimic*, which comes from the same root. Modernism's decisive move away from mimesis has been read as an expression of its independence from tradition and assertion of individual creativity.

Avant-garde

Avant-garde was originally a military term referring to the troops at the front of an army who push forward before the others (the English equivalent is vanguard or advance guard). In cultural terms, the avant-garde is that which pushes ideas and forms forward, often causing shock or consternation to those who have not yet caught up. The term began to be used in the nineteenth century, and so is generally used as a synonym for modernist, but it is sometimes used in place of contemporary art too. The avant-garde is always associated with radical disruption and is predicated on ideas of originality and independence of thought.

Formalist

Formalist interpretations of works of art are generally associated with the modernism of the nineteenth century and beyond. A formalist reading of a painting focuses on its formal qualities – brushstrokes, use of colour, composition and so on – above its narrative content or the context of its production. This kind of critical analysis of a work of art's visual appearance and manufacture was well suited to forms of abstraction in the mid-twentieth century, especially in the United States. Formalism remained a dominant strain of art criticism well into the 1960s, when it began to be critically assessed by writers who sought to consider other aspects of a work of art's meaning.

The Gaze

The gaze is a much-discussed term in art history. It is related to the power dynamics of looking, and is therefore intertwined with feminist and postcolonial theory. The concept of the male gaze is used to describe the dominant male perspective in art, and the assumption that a work of art is arranged for a male viewer and communicates his power. A good example of this is a traditional Western painting of a female nude, who seems passively laid out for heterosexual male contemplation. The term can be used to describe the point of view of a film camera too, both in film theory and photography.

Relational Aesthetics

This term was coined in the 1990s by French curator Nicolas Bourriaud to characterize a certain approach to artistic practice that was gaining popularity around that time. Relational aesthetics (or relational art) describes the kind of artwork that takes interpersonal relations, constructed by an artist, as its basis. A typical work in this category creates a situation, usually in a gallery or museum, that requires the interaction of an audience. The success of the piece, or even its shape, will be determined by the quality of the interactions between people that the piece itself generates.

Social Practice

Social practice art is predicated on the idea of collaboration and involvement, and is therefore somewhat related to both relational aesthetics and education projects. This form of art is not based upon the production of objects to be displayed in a gallery, although its results can sometimes take that form. Principally, the art actually takes place with the participation of others. It can often be tied into social and political activism, especially when artists engage with marginalized communities to enable them to articulate their own position within the language of art.

Abject

The abject is a common, if complex, category in
contemporary art, and also a description of certain
cultural forms of the past. Developed as an art historical
concept by French-Bulgarian theorist Julia Kristeva
in 1980, *abject* literally means 'cast off', and refers to
something that is discarded in order that the social
order might continue. This might refer to something
taboo, such as a repressed sexual urge, or morbid,
such as a corpse. There is a horror in being faced
with such material, which is sometimes exploited
by contemporary artists. Abjection can also refer
to socially marginalized groups.

Phenomenology

Phenomenology is a branch of existential philosophy that
concentrates on the study of the effect of phenomena –
in other words, things that we register with our senses.
In art history, a phenomenological interpretation
considers the relationship of the viewer's physical
presence and the work itself. In contemporary art,
certain artists focus on generating phenomenological
experiences that require a physical engagement with
art, rather than merely a visual or intellectual one.
Installation art is often predicated on this way of
thinking, in which an overwhelming sensory experience
obliges the viewer to encounter the work physically,
sometimes through touch, smell, sound or taste.

Deskilling

Much of modernist art since the nineteenth century has concerned itself with the dismantling of earlier traditions in artistic practice, perhaps above all the notion of the artist as virtuoso. The idea that art had become merely an expression of technical know-how, incapable of communicating anything more than that, led modern artists to want to divest themselves of skill and embrace the simplified, the naïve and the clumsy. Art's movement towards the conceptual and away from the manual in the twentieth century, itself a legacy of Renaissance attitudes towards craft, meant that discarding virtuosity stood for a rejection of the perceived superficiality of the well-made.

Simulacrum

A simulacrum is a perfect imitation of something in the real world. A simulacrum of an object, for example, will often be indistinguishable from the original object, or may appear uncannily realistic while being plainly artificial. Hyperrealism in art, which emerged in the 1970s in Europe and the United States, sought to create uncanny simulacra of objects and figures from the real world. For postmodern philosophers such as Jean Baudrillard, discussing global culture around that time, the simulacrum took the place of the original; the world itself was composed of a series of simulacra, with no original to which they could be traced back.

Art Forms

Allegory

An allegorical image uses imagery, often from classical mythology, as a means of speaking about something else. The narrative's hidden (or sometimes overt) meanings are generally intended to be read by a receptive viewer, who is able to see through the superficial events of the story to the messages contained within. Allegories often use human personifications of abstract ideas (love, victory, war and so on) in various combinations in order to create a readable image. Political images, in sculpture, printmaking or paintings, often make use of allegorical figures: the Statue of Liberty is perhaps the most famous example.

Memento Mori

The phrase *memento mori* means 'remember you must die'. Despite its morbid suggestion, this is the message behind a huge number of works of art from a range of geographical and historical contexts. The theme is best expressed through symbolism that is fairly easy to understand: a skull, an hourglass, or a recently snuffed candle naturally evoke the shortness of human existence. More oblique representations of the theme include objects that decay – fruit and flowers, for example – or things that don't last long – ephemeral bubbles or smoke, but also music, expressed in scores or actual instruments.

Genre Painting

Genre painting is itself a genre of painting, though one with a fairly broad definition. In seventeenth-century Holland, scenes of everyday, often (but not exclusively) working-class life became very popular. Images of domestic scenes, village life, gambling or drinking, and suggestive encounters between men and women were common subjects. Often, such scenes acted as forms of allegory, using quotidian narratives to convey messages about appropriate forms of social behaviour: an unkempt household in a genre painting might represent a subtle warning about personal responsibility, for example. Generally, genre painting depicted social types rather than identifiable portraits, and had relatively lowly pretensions, sometimes leaning on bawdy humour.

Devotional

A devotional work of art is created as an aid to prayer and meditation. Devotional works of art are very often also didactic, aiming for clarity of content and expression, but can be quieter in tone when designed for private use. In Christian art, small-scale altarpieces, sometimes built to be folded and carried, were often intended for private devotional use. Occasionally the patron of a devotional work of art might appear in the work themselves, thus underscoring the piety of that particular individual. Religious icons, placed in domestic spaces, are devotional too: they act as a locus for prayer and a means of channelling a person's relationship to the divine.

Portrait

All portraits relate to a known individual. They create a point of focus on that individual, either by representing them in painting or sculpture, or by using allegorical or symbolic means. A portrait may emerge from contexts of political or religious authority, economic power or celebrity, or it may be a more personal record. A commissioned portrait embodies the fulfilment of a contract between sitter and artist, which will have stipulated the inclusion and exclusion of certain elements. The idea of the portrait as true to life is a modern invention: ancient portraits evoked what the sitter represented rather than the specifics of their face.

Self-portrait

Depicting oneself in art seems to date back to the Italian Renaissance, and so might be associated with the reappraisal of artists as individuals that took place then. A self-portrait sometimes acted as a sign of the artist's own rise in status, and artists often depicted themselves without brushes and palette, as a kind of social climbing. By the late nineteenth century the romantic shift towards artists as outsiders led to an increased interest in self-portraiture as personal expression. The self-portrait became an almost diary-like means of self-examination and reflection. Self-portraiture as a way of making oneself visible has retained currency among artists from marginalized contexts.

Still Life

Still life became an independent genre in sixteenth-century Europe, especially present-day Holland; its name is a translation of the Dutch *stilleven*. The lowliness of still life's subject matter, and its usually small size, belies its ability to speak of grand subjects. Ordinary objects – fruits, flowers, books – might well take on additional layers of symbolic meaning when depicted in art; the act of representation is what charges these items with new value. As the easiest subject to assemble and work from, still life is associated with experiment and exploration, and as such was marginalized for much of Western art history in favour of more grandiose subject matter.

Landscape

A landscape is a representation of nature, not nature itself; nature is framed and mediated through the work of art. A seventeenth-century landscape painting carefully structures hills, trees and buildings to create a harmonious whole, whereas a nineteenth-century one may well be off-kilter, cropped, and loosely painted. Both are landscapes, and each represents a different historical idea of what nature means. Landscape art is always somehow about the human, and how humans understand themselves in relation to the natural world, which might be seen through an economic, technological or even spiritual lens.

Profile

A profile portrait is a representation of the human face from the side. As in the images of rulers on Roman coins, profiles tend to assert a sitter's noble bearing and social status. By not making eye contact with the viewer, profile portraits tend to convey a certain detachment and even superiority. During the Renaissance, artists started to experiment with showing the face in different positions, such as forward facing or three-quarters turned, which transformed a subject's relationship to a viewer. Female sitters tended to be shown from the side until well into the 1400s, their lack of social agency reflected in their passive presence in portraits.

Iconography

Iconography refers to a visual language used in art. Iconography usually manifests itself in symbolism, which can then be decoded, or translated like a written language, by anyone with the requisite knowledge. Christian art uses a range of symbols within its iconography, in which objects are taken to stand for abstract ideas. The term is also used to describe standard representations of certain scenes: for instance, the iconography of the Baptism of Christ. Because it is like a language, iconography tends to be limited to a certain range of possibilities. Iconographic analysis of works of art examines these representations.

Composition

The term composition is used within a variety of cultural contexts – perhaps most commonly in music. Essentially, a work of art's composition refers to the arrangement of its elements. In a Western painting, the composition is traditionally structured around simple geometric elements, like triangles or squares, which provide a certain sense of harmony; the composition, in this case, is the hidden structure of the painting itself. In modernist art, the composition of a painting may be all it consists of, as in a geometric abstract painting, or the artist might attempt to create a dispersed or 'all-over' composition, as in the paintings of Jackson Pollock.

Bust

A bust is a sculptural representation of the head and shoulders of an individual, usually with a base in a somewhat architectural form. The portrait bust originated in ancient Greece and became very popular in ancient Rome, where it was often used to depict emperors and political leaders. The classical bust maintained these associations during and after its revival in the Renaissance. Given its abbreviation of the human figure to head and shoulders, the portrait bust tends to focus on a likeness of the sitter's face and evokes their personality and character, rather than suggesting their worldly achievements, as in early portrait paintings.

Continuous Narrative

Rather than using a sequence of discrete frames as in a comic strip, a continuous narrative brings together a number of different moments in time within the same illusory space. Artists using such a strategy in visual storytelling have to devise ways of demarcating that space to suggest different episodes within the same narrative. Renaissance perspective allowed figures to be depicted at different spatial depths, allowing for a sense of past and present to be suggested through the use of foreground, middle ground and background. Such a strategy allowed for the illusion of depth to be maintained.

Foreground / Middle Ground / Background

In a painting using perspective, the illusory space of the painting is generally divided into three areas according to their apparent distance from the viewer. The foreground, which will often include foreshortened elements, is the nearest to the picture plane and might, in a painting using continuous narrative, be the most recent part of the story. The middle ground acts as a transition between the fore- and background and requires particular skill in suggesting the recession of space. The background is the furthest from the viewer, and is often depicted using diminutive scale or a fading of tone to suggest great distance and depth in the picture space.

Hierarchical Representation

One means of suggesting the relative status of figures within a painting or sculpture is to depict them at different scales. In ancient Egyptian sculptural reliefs, for example, the pharaoh is shown much larger in size in comparison to other figures, making his superior status clear. Medieval Christian art does something similar, showing the enthroned Virgin Mary at twice the physical size of a saint. These works of art existed at a time when a mimetic depiction of reality was not in the remit of art, and so huge figures would have been understood as symbolic, rather than literal.

Tonality

Tone, sometimes also called value, refers to the range of shades within a single colour. Any colour in a painting can contain a huge tonal range, which can be achieved in a variety of ways, including glazing and scumbling. Tonality in painting is particularly valuable in creating an illusion of volume in objects, and still life painting has traditionally been the genre in which an artist's command of tone can be most effectively expressed. In sculpture, tonal range can be generated on an object's surface through the careful use of depth and surface quality.

Anamorphosis

An anamorphic image requires the viewer to see it from a particular viewpoint in order to be able to register it properly; it is often illegible from any other position. In the Renaissance, an interest in anamorphosis in visual art is an extrapolation of linear perspective and an opportunity for artists, working in a crowded marketplace, to distinguish themselves from their peers due to their virtuosity. One of the best-known examples of anamorphosis is in Hans Holbein the Younger's 1533 painting *The Ambassadors*, in which a stretched grey shape in the painting's foreground is suddenly revealed to be a human skull when seen from a certain angle.

Complementary Colours

Nineteenth-century artists were fascinated by the power of placing certain colours side by side. This interest grew out of contemporary scientific investigations into optical effects, which formalized ideas artists had probably suspected for centuries. These investigations became widely read theories. When blue and orange, or red and green, or yellow and purple are juxtaposed, they will appear to be more vibrant to the viewer's eye. Artists such as Georges Seurat and Henri Matisse explored the effects of these juxtapositions in their paintings: this was an important step towards colour being treated as an independent thing in itself, rather than a means of mimetically representing visual reality.

Picture Plane

In an illusionistic painting, the picture plane is the invisible point at which the world of the painting and the real world meet. It can be imagined as a vertical transparent film through which the viewer looks into the painting. Some artists, particularly during the Baroque period, generated a sensation of immediacy and drama in their works by seeming to break through the picture plane. Modernist painting, from Édouard Manet to the abstract expressionists, often acknowledged the fiction of art by asserting the existence of the picture plane through flat areas of colour that seemed to sit on the surface of the canvas, on the viewer's side of the picture plane.

Trompe l'Oeil

This term translates from the French literally as 'fool the eye'; it is generally applied to works of art in which a mesmerizing illusion is the central feature. The idea of art that fools the eye was discussed in the very earliest accounts of painters' practices in ancient Greece, and is characteristic of many works of art in a wide range of styles and media, across the centuries. While easily dismissed as mere trickery, or at the very least an effect that suddenly wears off once its truth is revealed, trompe l'oeil effects can only be successfully achieved by artists of superior skill.

Golden Section

The golden section, or golden ratio, refers to a mathematical proportion that creates an effect of harmony and balance, used by architects, painters and sculptors since ancient Greece. This was particularly prized during the revival of classical aesthetics during the Italian Renaissance. Imagine a rectangular piece of paper. Draw a vertical line down that rectangle to divide it into a perfect square and a smaller rectangle. The smaller rectangle has the same proportion as the original rectangle; the same harmonious result will be achieved if you continue to divide the rectangle into smaller and smaller squares and rectangles. This proportion is often found in natural forms like snail shells, and has fascinated artists for centuries.

The Art World

Secondary Market / Auction House

Primary-market galleries show and sell newly produced works of art on behalf of the artists who made them. But many gallery spaces show works that have already been sold elsewhere. Any work of art, if sold more than once, is considered a secondary-market work. Provenance research will reveal a work's history and allow the gallery or auction house to decide on a price for the work. It can be the case that a work of art is worth less on the secondary market than it was when it was first sold. This is down to the unpredictable forces of fashion and taste.

Provenance

The history of a work of art – its journey from the artist to its current owner – is its provenance. Assessing a work's provenance requires a sometimes complex research process in order to establish its authenticity. This can help determine the resale price of the work, or an estimate if the work is being sold at an auction house. Before a sale, provenance can be used to tell a desirable story about an object to generate interest in it. Provenance research can also reveal a darker history and expose the work of art to potential restitution claims if it was ever illegally seized or stolen.

Attribution

An attribution is a decision about the authorship of a work of art, which is always the result of scholarly examination and justification. The attribution of works of art often changes over time, especially as the technology used in examining them becomes more sophisticated; deattribution is the term used when a work's authorship has been re-evaluated. If an attribution is not certain, museums might use terminology such as 'workshop of' (made in the artist's studio, by an assistant working under the named artist's supervision) or 'follower of' (in the style of that artist, but made by someone not directly associated with them).

Forgery

A forged work of art is a fake that has been falsely attributed to a well-known artist. An effective forger of works of art must have advanced artistic skills in order to create a convincing illusion of an authentic work, as must those who intend to apprehend them. Increasing financial speculation and the growth of new markets has led to a rise in forgeries in the art market in general. Some forgers have become well known in their own right, and their works are sometimes valued by collectors. The most skilful forgers even used antique canvases and historical pigments to fool authorities.

Masterpiece

This term implies a consensus on the high quality of a work of art, usually generated by a weight of critical attention over a long period of time. The lasting fame of an artist is predicated upon their production of works of art that have received a certain amount of attention from those whose reputations are at stake. The term *masterpiece* is consequently not lightly used. Justifying its use, however, proves challenging, given the absence of unchanging standards of beauty and quality in art and the numerous vested interests at play in any use of the word.

Condition Report

Every work of art in a public or private collection will have its own file, either physical or digital, known as its condition report. This document details the physical condition of a work of art and its frame, where relevant. Because works of art invariably change over time, the condition report is a vital tool in tracking the nature of the change and is a means of ascertaining the need for restoration and conservation. Every work of art in a museum will be regularly checked in case of damage by temperature, light or visitor behaviour.

Conservation

The conservation of works of art refers to the process by which their condition is maintained and preserved. Preventive conservation focuses on protecting works of art from damage and decay; works are analysed for evidence of any environmental conditions or the proximity of pests that might cause harm to the artwork. Regular monitoring of display, storage and transport areas is crucial in preventive conservation, which is intended to reduce the need for in-depth conservation and restoration. Conservators are skilled in scientific analysis of the materials of art and the conditions under which they can deteriorate.

Restoration

Restoration of a damaged work of art involves an act of repair to restore to that object some of its original qualities. The techniques of restoration have changed dramatically over the history of art collecting, and differ from country to country. Scientific advances have allowed restoration techniques to become ever more sophisticated. Restoration nowadays is often reversible, in contrast with the earlier twentieth century, in which extensive repainting permanently altered the appearance of certain objects. It is safe to assume that all works of art of the past have been restored, sometimes many times and often to the point of complete transformation.

Connoisseurship

A connoisseur makes judgements about attributions of works of art based on the visual evidence of the object itself. This requires a close, almost forensic examination, as well as a comprehensive knowledge of the history of art, techniques of manufacture and the condition of works of art. As academic art history moved away from formalist or stylistic readings of art and towards an examination of the social and political contexts in which the art was made, this approach became somewhat discredited, but connoisseurship remains an important skill in the art market and is an underrated aspect of art historical practice.

Deaccession

Deaccessioning is the sometimes controversial practice whereby a museum sells off items from its collection. Since permanent collections are at the heart of a public museum's identity, the removal of works from that collection to be sold to private collectors can be read as a contravention of a museum's mission. In recent years, however, museums with collections that are no longer seen as representative of the populace of the countries they are situated in will sometimes sell more traditional works in order to buy replacements that reflect more diverse backgrounds and positions.

Turner Prize

In the United Kingdom, the Turner Prize has become synonymous with contemporary art, and was the means by which many of the general public became aware of it. Inaugurated in 1984 and named after the romantic painter J.M.W. Turner, the prize is awarded to an artist working in Britain, or a British artist working internationally. The shortlist of four artists is decided by a panel of critics, art historians and art-world professionals, which is changed every year. This panel selects a single artist to win the prize, which comes not only with a cash award but also a high level of recognition and sometimes criticism too.

Patronage

The system of patronage dominated art right up to the foundation of art academies in the eighteenth century. It is a safe assumption that the best-known Western art made during the Renaissance period was paid for by an individual or group, as there was no open market for the sale of works of art. A patron might be a monarch, religious leader or private individual keen to see themselves reflected in the work they paid for. Patrons would commission works of art from artists and often specify the content of the work, which could make reference to the patron's family, profession or political affiliation.

Manifesto

Artists in certain twentieth-century art movements wrote and published manifestos – essentially, lists of objectives – to which their work was intended to refer. The Italian Futurists published theirs on the front page of the French newspaper *Le Figaro* in 1909; manifestos from many other movements followed, including Dada, suprematism, De Stijl, surrealism and so on. Publishing a manifesto allowed artists to gain a public following, or at least notoriety. Despite the fact that the aims of manifestos were not often reflected in the art itself, the existence of manifestos revealed artists' desire to create their own art worlds outside of the academy.

Decolonization

Decolonization is a process of self-reflection undergone by museums founded in the heyday of Western colonialism. Recognizing that their audiences have changed, as well as the questionable provenance of objects in their collections, many museums are attempting to right the historical wrongs on which their institutions were founded. This might mean revised deaccessioning policies, new interpretative approaches, or working with communities from which certain objects may have been appropriated. In essence, decolonizing means no longer treating the museum's voice as neutral, and acknowledging that collections and displays are an expression of power in need of critique and analysis.

Art Spaces

Kunsthalle

The German word *kunsthalle*, which is never translated into another language, means 'art hall'; it is a commonplace institution in the international art landscape. Unlike a museum, a kunsthalle has no permanent collection of its own, and is used as an architectural space in which a rotating series of exhibitions is held. Because of this, it lacks the means to lend works of art to other institutions. The advantage of this apparent shortcoming, though, is that a kunsthalle can often be more flexible in the kinds of artworks it shows.

Wunderkammer

The Wunderkammer, also known as the cabinet of curiosities, is the ancestor of the modern museum and shares many of its characteristics. Emerging in Europe during the Renaissance, the Wunderkammer (from the German, meaning 'room of wonder') was a way of displaying the private collection of an individual, usually within a private residence. Objects – often bizarre specimens and strange items alongside works of art – would be displayed on open shelves and in drawers that could be pulled out and inspected. Wunderkammers were at their most popular during the early years of Western colonial expansion, and collectors used them to display objects that attested to their travels and commercial interests.

Galleries

A primary-market gallery is a space in which newly created works of art are sold. Galleries tend to represent living artists who may have something in common (medium, style, nationality or approach). It is conventional for galleries to take a significant percentage of the sale of works of art, in exchange for regular exhibitions, press coverage, access to collectors, and perhaps representation at international art fairs. A dealer or gallerist acts a little like an agent for a band or actor, seeking to raise artists' profiles and ensure they are represented appropriately and their works are placed in prestigious private collections.

Museum

There is no fixed definition of a museum, and museums regularly assess their mission and meaning. Museology, the analysis of museums and their history, treats museums as spaces in which political and national power is articulated through the display of objects. But this is far from the only function of museums. Museums not only display objects, they also undertake their conservation, restoration and interpretation. Museums also educate, providing a space in which diverse audiences can engage with objects. In recent years, the awareness of museums' need to serve their audiences has led to changes in the nature of exhibition programming, collecting and collection management.

Biennial

Biennials tend to be large-scale, non-commercial exhibitions of contemporary art that take place once every two years in a specific location. The original and best-known biennial started in Venice in 1895, but there are now hundreds taking place all across the globe. Comparable to biennials but on a slightly different model are events such as Documenta (which takes place once every five years, in Kassel, Germany) and Manifesta (a biennial exhibition that moves to a different location each time). Curatorial approaches in biennials are carefully observed and often imitated, so they can be testing grounds for new ways of displaying and thinking about contemporary art.

Curator

Deriving from the Latin for 'look after', curators were originally scholars attached to a museum. This remains the case, but curating in contemporary art has taken on a very different meaning. Shifts in artistic practice since the 1960s away from the creation of objects and more towards interactivity, performance and institutional critique made artists themselves more involved in orchestrating events and arranging spaces, and even curating art collections themselves. This new kind of artist/curator became an especially powerful force in the contemporary art landscape from the 1990s onwards, when curators began to acquire a celebrity-like status.

Studio

The studio is a complex notion, since the ways artists work have undergone so many transformations over the centuries. For centuries, studios were bustling places: artists in Renaissance and Baroque Europe would have had young assistants grinding pigment, preparing panels, stretching canvases and even doing some of the painting of the final work. By the late nineteenth century, the studio had become a much more private place, where increasingly introspective and personal work could be produced. Conceptual artists might not have a studio at all, and the term 'post-studio' became a means of defining this different approach to an artist's working space.

White Cube Space

A white cube gallery space has the appearance of neutrality: white walls, a concrete or plain wooden floor, bright electric lights, and no windows out onto the street. The effect is that of a clean, rather antiseptic space. This kind of display is the norm in the contemporary art market, but has only become ubiquitous since the 1960s, when certain kinds of contemporary work, minimalism especially, demanded a setting with little visual distraction from the pared-down aesthetic of the art. Critics of this display strategy have noted that it turns the gallery into a kind of shrine, giving the objects inside the quasi-spiritual aura of relics.

Art Fair

Not all art fairs focus on contemporary art – there are many fairs of old master painting and decorative arts – but contemporary art fairs tend to dominate the landscape, with Art Basel in Basel, Miami and Hong Kong and the Frieze Art Fair in London, New York and Los Angeles probably the most significant. Primary-market galleries now focus their attention on these fairs, which the wealthiest and most important collectors attend. Costs of exhibiting at art fairs can be very high, so making sales is galleries' top priority. Enhancing a gallery's profile is of secondary, but also high, importance.

Freeport

A great deal of great art is not visible. It could be in museum storage, or it might be in a freeport, a vast storage facility that exists outside of the jurisdiction of the country it is located in. Effectively, freeports are tax-free locations, and have been used by the international art market as a means of storing works of art without having to declare tax on any purchases. Those using freeports to house their art collections are banking on making a return on their investments, rather than buying works of art to look at.

Ethnographic Museums

Nineteenth-century European cities often contained ethnographic museums, in which objects from a wide array of non-Western contexts were displayed and interpreted. These objects were generally the fruits of colonial expansion, and as such their installation in these museums could be read as a kind of celebration of the global reach of Western powers. Such museums typically contain an array of global artefacts, from African and Oceanic tribal objects to pre-Columbian and Native American art, all removed from their social and cultural contexts. As the academic study of such contexts has increased in sophistication, so has the interpretation of these objects by museums.

LAURENCE KING

Published by Laurence King Publishing
361–373 City Road
London EC1V 1LR
United Kingdom
Tel: +44 20 7841 6900
Email: enquiries@laurenceking.com
www.laurenceking.com

A catalogue record for this book is available
from the British Library.

ISBN: 978-1-78627-693-3

Design: Alex Wright

Printed in China

Laurence King Publishing is committed to
ethical and sustainable production. We are
proud participants in the Book Chain Project®.
bookchainproject.com

**BOOK
CHAIN
PROJECT**